She is the Sea

She is the Sea

a poetry pamphlet
with
one shoreline essay and one riverbank essay

Crab & Bee

(Phil Smith & Helen Billinghurst)

Published in 2019 by:
Triarchy Press
Axminster, England

info@triarchypress.net
www.triarchypress.net

ISBNs
Print: 978-1-911193-71-5
ePub: 978-1-911193-73-9
pdf: 978-1-911193-72-2

.

from land through the deep to land again

In 1993, I (Helen) arrived on the Isles of Scilly with a crew of student filmmakers to direct a short film I had written for my Final Major project. The film, 'Island Tales', interwove several themes. I had come from London to study filmmaking in Plymouth, and this film was my response to 'travelling west'. Narrated by children, the film told several entangled stories, including those of giants, shipwrecks, Tristan and Isolde, a mermaid and Barinthus, the ferryman to the Isles of the Blessed. I remained in the South West and five years ago I began a 'practice as research' project eventually titled 'English Diagrams'. This time, I made work (paintings, drawings, assemblages) in the studio in response to a walked journey east across England towards my childhood home in Cambridge. Once again, several 'voices' arose out of my body and through the practice, to tell entangling tales of the places I walked through. Nearly thirty years later, I found myself re-working some of the images that had arisen in 'Island Tales'.

In 2006, I (Phil) travelled to the Channel island of Herm for the site-artists Wrights & Sites. Disembarking

from the early-morning boat, I picked up a leaf from the quayside. Later, perusing a map of the island over a beer, I noticed that the leaf and the coast of Herm were a similar shape. So, I traced the veins of the leaf onto the island and attempted to walk them. This tactic for walking islands was later published as part of *A Mis-Guide to Anywhere*; such combinations of mapping with the patterns in small things and a walking off the official path still inform my work in Crab & Bee.

These are not the only continuities in the work of Crab & Bee. Despite – perhaps because of – our very different life paths, we often draw on our past experiences, as art makers and as people, to steer the work we do. Without revealing which of us is which, at least one of us has worked in a jail, was active in a key flowering of the rave scene, worked on the floor of warehouses where legs were broken by forklift trucks, unknowingly billeted an ex-member of the KGB with a serving MI6 officer, attended the famous 1970s' Albion Fairs, has written over 150 plays seen by audiences from Lima to Istanbul, writes about Christine Keeler, worked as a film editor until walking out on a job promoting missile systems, walked from Manchester to Rutland, and marched in Dresden against the dictatorship of Erich Honecker. Despite both of us having bad experiences with school, we both have doctoral degrees, one in studio practice and walking, the other in counter-tourism.

We talk a lot to each other about how we do things and the ideas and methods that inform and shape the 'how'. We are not embarrassed about getting excited by theory. We like it if a project drags in questions and quandaries and, then, spills them out as artefacts to entangle with audiences, objects and other species. Our methodology is mutating all the time, partly driven by new practical challenges and partly

by its own contradictions. We are not even particularly consistent in our single selves. I (Helen) emphasise flows and work with diagrams, while I (Phil) focus on textures and assembling mental orreries with no sun at their centre, tracking the orbit of their wayward ideas. Where we have both been consistent is in our valuing of walking, our putting our bodies in the landscape and ourselves 'at the mercy of' the terrain, letting the land guide us and trusting what we feel there. Most of what we see, what we hear, what we feel, is not available from a car seat.

Let us be clear, though; this may not be the 'walking' that right now you are imagining us doing. It has little or no connection to a ramble to 'appreciate the environment and nature' or a stroll to enjoy 'the view', 'the countryside' or 'peace and quiet'. For us, walking is something much closer to Butoh dance than a ramble or an afternoon stroll; we do not shy away from unsung, abject places in extreme distress, we engage with the grotesque and hilarious. We use our bodies – not just our senses, but also the sheet of fascia, jelly and gristle inside us – as hypersensitised litmus paper for detecting the signal hidden within the signal; a covert pattern we are coming to understand as the map that has always been partly there, guiding our walking; a choreography we simultaneously follow and invent.

Walking in Plymouth for our first project, we were repeatedly stunned by how quickly suburban roads disappeared and woodlands began; how close to the streets were wooded streams and ponds. What from the road looked like a couple of trees in somebody's back garden would turn out to be an expansive forest with a derelict Tudor farmhouse, a disused quarry and a racing brook. These are the places you will never find if you only ever walk to destinations – shops, work, cinema – or always follow a guidebook. Some places are

only arrived at if you go without a target, if you meander, wander, go sideways, follow feelings rather than signposts, and hypersensitise yourself.

We often feel like we are skulking around, that we are in places where very few people go. We like to keep a low profile, move quietly and let the landscape unfold itself. We look like harmless ramblers, coastal path followers; neither security guards nor drug dealers see us as much of a threat. We are not disguised. We go with the flow, so we can keep our senses open and fixed on the things around us; we put aside what we may think we know, we trust our bodies to tell us about a place, and trust the place to tell us through our bodies. We start from our senses and then slowly let more and more people into what we find.

We might hypersensitise ourselves to a place by walking with a theme or an idea associated with it, or by walking with things, like symbolic food or drink. On a walk to a coastal fort built by a paranoid British government against non-existent seaborne French and Russian invaders, we carried French cheese and Russian vodka to celebrate the peaceful incursion of overseas foods. We might carry chalk to draw with or ash to sprinkle, stories and poems to read along the way, matches to light a fire of driftwood on the beach. Each thing is used to turn our attention back to the terrain, each place changed by our presence in it.

We sometimes walk in silence. Most of the time we are in dialogue; always about the walk and associations triggered by it. We share memories, philosophical ideas, fictions and movies that a place reminds us of, each different thread weaving together into a web that is unique to the walk. Sometimes we talk things into being. By describing to each other how we would like things to be, they sometimes become like that. We describe to each other a different way of

feeling and find we have started to feel differently. The walk is about being open to other things, but the walk is made by the walkers.

We also make 'almost-performances': actions like lying down in fields, sitting against trees, scrying in pools, washing our faces in holy wells, lighting fires by the sea. And we fiction. We act as if we are in stories. Old lamp posts take us to Narnia, clay pits conjure a Dr Who wasteland; we have become characters in a changeable story rather than trapped in a system that few people believe will ever change. Fictioning – the inventing of an ancient past, or a 'sci fi' future in order to change the present – is an idea we have borrowed from the artist/theorist Simon O'Sullivan. We inhabit such fictions as we walk; they change our lives. Some are speculative and race to a place far ahead where we meet them again later. Trivial details reveal themselves as important. Legends turn out to be accurate.

When all the things spin together – the philosophising, fictioning, collecting, touching, listening, dialoguing, learning – what develops is a Web Walking, a cat's cradle of actions and ideas and sensations, a meshwork that supports multiple identities and links one place to another, one species to another, with threads crossing from thing to stream to sensation to story to crow. This Web Walking is about connectivity and the spinning of yarns. There is huge pleasure to be had just walking in this hypersensitised state, connecting physically and emotionally; the threads of the walk spinning out into something different, sometimes very quickly. By refraining from bringing things to an immediate realisation or conclusion, it seems we can more easily connect the different threads of our walking, fictioning and improvising practice to others, human and unhuman.

For our first project, we were sometimes writing on the walk itself, or collecting found objects. We began by treating Plymouth as an island by walking around its peripheries and its coast, along tidal estuaries and coastal paths, but just as frequently we walked along the dry beds of diverted rivers, or along the backs of retail parks, where Dartmoor rubs up to the edges of the city, where its waters and its old leat enter. Tracing the city's shimmering coast or under its saturating rain, we wrote poems and made rapid drawings on postcards that we posted ahead to where we would eventually be exhibiting. Immediacy kept the poetry flexible, and we were quickly repurposing what we wrote across different mediums, from one scale to another, and into new ways to share. Much to our amazement, we found ourselves regularly appearing at readings to perform our poems, then repurposing them as rules for paintings or liturgies for a scrying in Cardiff or a 'working' in Plymouth for the opening of our exhibition.

At the same time, we sought resistance, wrinkles and stubborn myths, while planning for a future living with poisonous waste matter; for a future with abject long-enduring plastics and the ruins of economies that were built with planned-in obsolescence. We sought alliances against the epidemic of 'short-termism' we found all around us: from developers who add 'improvements' and have lost interest in them two years later, to the transfer of sludge full of microplastics from water treatment plants to fields inland, to flood defences that accumulate surface water and accelerate its journey to the next community along, to sex industries and red light districts, to a navy that has made no plans for its redundant nuclear submarine reactors and has left them rotting in a nuclear graveyard within the heart of our city. Rather than offer bursts of utopian hope or apocalyptic ecstasy, which do nothing but reset the status quo after a brief

excitement, our response to short-termism skirts around more conventional ecological tropes and conservationist rural sublime. We favour playful and grotesque experiences, in extreme settings, and being with people and unhumans in distress. We seek in our poetry the inconvenient and cussed things in the urban flow – rusting boats, bin bags caught in trees, the rhythm of an allotment – that work as creative inhibitions and poetic drags upon short-termist thrills and self-destructions. We season pleasure with 'jouissance'; and within the exceptional joys of our adventures and through the rush of the over-excited climate crisis, conjure a reminder of the death we have in common.

The poems that follow come from our journeys in Devon, France and the Isles of Scilly.

Crab & Bee

Circular Story

I am rows of houses
a mausoleum menagerie of stone animals,
the wheelie bin tethered by flesh-coloured tights.

I am the climbed hill,
the trees at the top,
I am where you both stood still
and shivered:

I am the shift
of something imperceptible
perhaps a drop in temperature,
or light.

I am the old stone Lane
on the journey down
to wind you up
I wind you around:

a circular story
of a circular walk
inside
a circular story
of a circular walk.

What You Don't Do

What you don't do is what makes you
And how you connect to it.
Empathy is an organ that grows secretly
Within the most surprising of uniforms,
In thick skins and deadpan conformists;
And it shrivels in frustrations with others,
In cheated liberals and the mists of careers.

What you don't do is what defines you,
If you find a way to appreciate it.
To value those you hold no loyalty to.
Applaud at football matches the lives of fans you never knew.
Insubstantial and invisible jests which hold a universal mesh in place,
A highway of spirits that makes the whole thing beyond Pluto
 intuitable.

Where you don't go is what forms you
And how you navigate its subtle changes of orientation,
Hypersensitised to stories of Mars on walks
To the bar and the burial mounds of here and now.
How you make there and then, the Barbie and Ken
Of your religions, hobbies and acumen.

Where you are naff, innocent, self-denying and enigmatic
Is where you make the dark and slithering sculpture within,
The slippery thing of you, that only lovers can hold on to,
Should hold onto; the prize no one can win.
And how you don't allow the demagogues access
Is what preserves you and what you are,
And can be best, allowing all the rest of you
To have its slinky darkness, its risky tenderness.

What you are not showing
Is what you will be loved for;
The unappropriated, hidden, lush ravine
You will not recognise in yourself
Is that gulf others come to huddle in;
What you are not is a lot of what you've got.

Incident

Did you say they were children?
The light was odd, almost dusk, the playground had been busy
 earlier, emptied
now, we'd been staring at a
hole in a tree... yes, children.
I think we'd got confused by the watershed, the streams
going off to different rivers, it was a time of crisis,
nuclear treaties getting torn up, what was happening to the ecology,
The light was very greyish brown and buttery, but they shone...
The children?
Three of them, it was the main one, though... I don't even know
what I mean by that... she came down the path and met us;
said, forcefully:
"do you want some chocolate?"
Can you describe her?
No, not really. She wore mostly red, a bow in her hair read:
"share the magic", some sort of Disney thing, I think...
What was so strange about that?
I have no idea; but they could give us
no explanation why they were doing what they were doing, and
If you can't give an explanation for something, is it really there?
Do you think they weren't really there?
I think there was something there.....
Go on...
I thought they were selling things. We both did. You know,
children setting out a stall on a pavement, we'd been caught out
 by kids before,
the boy's t-shirt read "MONSTER"; the other girl seemed
 embarrassed by her role,
they were all quietly out of control, I think we saw ourselves in them
and were unnerved, all sliding down the same slope together;

only the main one had conviction...
What do you think they were doing?
Giving away chocolates
and sugary drinks the colour of traffic lights...
They didn't want money?
I don't know what they wanted... they didn't know or
Couldn't say, and that's why we were
so quick to refuse, frightened by the impossibility of this little
 magic island
of generosity led by a red princess, a place meaningless in all
 languages,
except theirs, unreportable on any of the available channels,
a fairy story of children
giving sweets to strangers, and all arks wrecked.

Plastic

I am plastic.
Invoked by human,
out from under the earth I came,
Death, drawn and dragged up from the dark deep,
to smother, to bring life back down to itself.
One of the seven cellophane seals of the polystyrene apocalypse.

I am a lurid, spiteful spook.
Animated by the air, I haunt margins everywhere:
I am crisp packet swirling on a gust of wind.
In Spring I am a flimsy phantom, flapping in the layby,
settling on early primroses on the banks of the A38.
Midsummer, I am the woeful wraith wafting over hot tarmac,
 under your wheels.
A batwitch binbag, snaggled by the topmost twigs of the chestnut
 tree in Autumn,
a black bauble hanging in the Winter holly.
I am the disinterested genie of bottles manifold
I serve no one but myself.
Water was in me, now I am in water:
Plastic, plastic all around
Tory Brook, Plym and Tamar,
Microplastic Plymouth Sound.

I am the see-through spectre of separation,
clinging filmily
to your food,
your guts
your DNA

I am plastic
You are plastic
We are plastic/human hybrid
Out from under the earth we came,
Death, drawn and dragged up from the deep dark,
to smother. To bring life back down to itself.
One of the seven cellophane seals of the polystyrene apocalypse.

On the Island

You cannot write the poem of where you haven't been;
There's nothing between a shore and a breaking wave you
 haven't seen.
No froth on stones in restricted zones or
Life in juggled goodnesses. No plans in sand,
Smoothed remorselessly, ever become a diagram.
Strangled with torn driftwood
On the cormorant line between
Dusk and dawn. Everything arrives
Incomplete; repeating nothingness, it breaks the initiate's feet,
Ha ha! Washing his liturgy in salt, wiping his ritual with
 barnacled kelp.
No one can work a magic they learned, not felt.

Alain Prillard, Monpazier

I am the slip in time
a glitch in place.

I am the exhibition.
I am the cool cellar
underneath a
hot,
English-built
medieval square.

I called two people here,
across the sea
from over there

one by one
they came,
they looked
and left again.

Allotment

On the side of the valley is a garden with burnt sheds and
blackberries
glass in the ground.
A metal fence with padlocks all around.
All around I am all around
the roar of the Albion fans in the football ground.
I am the pond in three buckets
The deep time chime of Cathedral bell
Sloe worm found.
All around, I am the ground.

Gogmagog Speaks to Brutus

you can fuck off back to Troy,
if you're not serious enough to go
blind and gain the gigantic sense
that everything's
gone frantically wrong!

or to learn another way;
study mystery, bright
as moss that burns in caves,
delightful as flying kites in the sea;
a thread reaching through waves,
feelingly.

So you think I'm dead!
No, I was never so weak, but
after you dismembered my brothers, baited me with dogs,
set my children shivering, forced me to speak,
I remembered.

I am the child of twenty-nine Syrian princesses
driven rudderless on angry seas,
sprout of fearless liberal huntresses who strung
husbands and brown hares on similar pieces of twine.
I am a child of rock,
trees, gooseberries, bramble buds and
refugees, no sails fail me, I am Gogmagog,
I am egality, no one need bend a knee to me; I'm
already bigger than an Admiralty,
big enough to be all that we will ever need to be.

Gog

He is baby Gog:
petulant child of cracks, crevices,
and terrifying tantrums.

A mini monster.
Boulders for brains,
ham-fisted, cack-handed,
furious with frustration.
Pockets full of string, shells, jagged rusty metal, broken glass,
ivy and brambles for hair.

In rage, he shook his creamy milkshake until
the sea turned white,
then hurled the styrofoam carton
onto the shore.

He grizzled,
then ate the beach:
chewed and spat out sand,
gnawed at rocks with pebble teeth,
stamped on seagulls,
bit heads off pigeons,
screamed at the sea,
lay on his back
and
sobbed at the sky.

She is the Sea

and the sea loves her
she is as old as contempt, and
as young as abandonment
her hair is a flotilla of sea snakes
the waves on long journeys, all different, diffident,
her identity shifts, intermittently, she comes in ships;
judderingly,
spicy cargo; even the stevedores
handle her warily, respectfully; she kisses the dock,
she leads the slipway astray
no one knows what's wet or dry,
sea or shore, night or day,
anymore
her three hearts are stone
her locks a mindless kelp
she is help in a storm,
a tinker unfixing norms,
the fierce leader, her prow set into rollers
hares stream like tears
over her clinker skin
she lives in one of the flats
after she's dropped the kids off at school
she sits for five minutes, as a rule,
and looks out at the boats
and dreams of Syria, Greece, anywhere
but here
tonight she will launch the boat between the rock monsters
slip away with a navy of dreams
to the deep sea ocean trench
where she can be just as she seems
to herself

the queen of the old ways
men and women chase her in gigs and trawlers
putting aside their lack of motivation
they haul her up in nets
she hid beneath the boat in Galilee
as she escaped between a grid of creels
she is heretic, she's lobster
she makes a brown magic
cultivates a green mind
she throws out questions like so many tentacles
she stings like ivy, burns like a shrine
she commands the loyalty of friends
she refuses war
hunts remorselessly for peaceful ways to settle scores
she does nothing newsworthy
so things pass her by, no one stops and turns, tourists go,
tourists come,
but nothing of Old Albion returns
the realm beneath her tresses
that she's founder of:
the dreams of thirty-three princesses
that she's chandler of,
launcher of desirous barks,
planter of seeds, complicated thoughts
she lives in the flats
no one knows any more about her than that
but tonight the sound of grinding will come from the beach
rust, reinforcements and public art bent
by a keeling grip on normality
she will slip in among gossiping kelp
and push off between monstrous rocks
her hands on the soft tiller
sails flail from her chest
two streams of milk in the sound
silent doubleness of sleep

as a queen and her thirty-three desires,
her animal lovers, spirit followers on Instagram,
and her dreams,
return to the addictive deep.

What the Kelp Says

Curl brine gurgle
Swarm rush bubble
Surge bait drench
Fronds
There is only me, says kelp
There is only green in heaven
and only green in hell
there is one part of the ocean
that is only kelp
The rest is best forgotten
Kelp wants to overwhelm the universe
Kelp is angry, kelp drinks all night
And all of the day
Kelp favours oil-based toxins
Ethanol, petroleum and soft furnishings
Kelp is envious
Kelp is an aspiring mob
Kelp is mindless violence
Kelp is kindness
Kelp is everything, says kelp
Including its own nemesis
Kelp is capitalism
Kelp hangs out with rock
Rock puts up with kelp
Kelp thinks rocks are boring
But sticks with rock for security
Rock thinks kelp is superficial
But likes the fondling fronds
When the waves pull in and out
Regularly
Rock is out for itself

Kelp thinks that it's the thing that everything else is out for
Kelp doesn't understand people's attitude to rain
Kelp likes to think of itself as broadminded
Kelp remembers the Burning Years
When kelp was compost
Kelp was toast
The past is what Kelp fears the most
Kelp says it's not the sea goes up and down
It's everything else, it's a trick kelp and rock play on humans
Kelp says no two ripples are the same
They're duplicitous, Kelp says
Kelp likes to be popped
Kelp hates to be ignored
Kelp will be the last thing left
Before nothing is for evermore
Kelp says

working with flow

tracing unsung waterways through artistic collaboration

In 2018 we began to plan a project for the city of Plymouth. We wanted to bring together our separate walking art practices and channel our existing explorations of the less cared for spaces in Plymouth. The project was called 'Plymouth Labyrinth' and drew from Olaf Nicolai and Jan Wenzel's premise that there never was a labyrinth under the city of Knossos, but that the labyrinth was the city itself. We wanted to use the myth of Ariadne and Minotaur as a lens to interrogate Plymouth; to disrupt clichéd narratives of the Armada and the Blitz and explore the routes and stories that weave together to form this place.

We had no idea how important the water courses of Plymouth – and eventually of Britain – would become for us,

as we developed a model of convivial and collaborative myth-making and art-production we now call Web Walking. Our practice began with walking the winding, ever-shifting tidal estuary paths towards the north of the city. Early on, we noted how entrancing this winding could be, opening us into hyper-receptive states of noticing and listening to the landscapes. We repeatedly observed long, green recreation areas at the bottom of the city's valleys. On consulting the maps, we found that these were places where rivers and streams had been thwarted and drained, or entombed underground and deployed as sewers. Today the roads in Plymouth twist and turn to navigate the valley shapes left by these missing rivers, keeping Plymothians in a constant state of giddiness.

We took to following water courses overground and tracking the ones below. Where the flows were interfered with, the atmosphere is often heavy, draining and oppressive. We walked one day, feeling exhausted, along a valley with a line of crackling pylons sited over the course of a small stream. Here, we found discarded needles and bright plastic in the city woodland, and orange-red water flowing out from underneath an ominous Palmerston fort, stained by the rusting iron in the frame of the building. On another day, we followed the unwalked side of a stream to find a ruined farmhouse and a swathe of ancient forest with mighty trees hidden in the middle of the suburbs. Later, we followed a creek towards the Tamar to find an abandoned ark. Under the Hoe, we invented a game called Sea Kites and with two micro-plastics scientists we walked around the Laira River from one water treatment plant to another. On the Teats Hill slipway we celebrated the myth of Albina – the founder of Albion – and her thirty-three sisters arriving by boat from Syria.

Though we might have anticipated our immersion in these spaces, what surprised us was the way that they responded to us; through their personalities, their amoral forces, their materials and textures and flows. New images stepped forward, and in turn these images became absorbed into the artwork we were making: poems, paintings, postcards, walks and performances. In these artworks we tried to describe what it was that seemed to reach out to us along these water courses; sometimes as forces like gravity, sometimes as 'gods of the earth' like Pan and Arachne.

After the 'Labyrinth' project had finished, we wanted to find out whether what we had learnt in Plymouth – our Web Walking model for art-making, conviviality and connectivity – could be applied in other places. So we began a series of walks across the country. In the Isles of Scilly, on St Mary's, we were surprised to find our way immediately to the woodland in the centre of the island growing out of the black bog water of Holy Vale. In Dorset we found an ancient path that was both a road and a stream. We noticed patterns: in Bristol, people had been setting fires above the route of the underground Malago River in the same way that they had set a fire over an underground sewage system in St Mellons, in Cardiff.

We paddled our feet in the water at Springhead in Ashwell, Hertfordshire. Though there are no clooties, charms or trinkets there, there is a tacit agreement amongst the locals that this is a magical space. And a longstanding one, too; for a collection of early Neolithic flints found in a garden near the springhead suggests a very ancient ritual activity, while in 2002 a find of twenty-seven gold and silver engraved votive objects revealed Ashwell as an important Romano-British site of pilgrimage for people from as far away as Spain, coming to take the waters, petition and make offerings to a water goddess called Senuna – an ancient British goddess

appropriated by the Romans and spliced with Minerva Fortuna. Senuna's cult may have been linked to that of Sulis at Bath and of Sena or Sillina in the Scilly Isles, where a temple site and a comparable hoard of Romano-British votive offerings were found on the island of Nornour, which may be the 'Senna' described almost 2,000 years ago by the Roman geographer Pomponius Mela as being famous for its oracle and nine priestesses who were able to "call up the seas and the winds", heal, predict the future and shapeshift into animal form at will.

In Cheddar Gorge we visited Gough's Cave to hear of Nancy Beauchamp who lived in front of the cave in the early nineteenth century, bottling its restorative waters for passing travellers. Two days later, in Glastonbury, we attended another spring in the unlikely setting of a Victorian pump house that had been a tea rooms until ten years ago. Here, we witnessed an old story repeating itself in a new place; for in contemporary Glastonbury (unlike Ashwell, for now at least) those who visit are not shy about their reverence for the water. Imbibing, ablutions, naked flesh, candles, incantations, prayers, rituals and ribbons are all part of a setting that would likely be familiar to the oracular priestesses of Senuna.

All these places had powerful ecological and material impacts upon us, and here are just five of our findings:

First, while planning our trip to the Scilly Isles we re-saw Plymouth as an archipelago. The marginalisation of the city's suburbs, often cut off from access to community resources and necessary services, is in part a symptom of the loss of watery channels of communication.

Second, walking by river and sea with microplastics scientists, we learned just how far plastics have penetrated living organisms, including ourselves. Plastic now connects us

in a continuum with the global water system; any future in which humans figure is one that we share with plastics.

Third, the fires we found in St Mellons, on the edge of Cardiff, and above the culverted Malago River in the Bristol suburbs, the pattern of lighting fires over the movement of hidden water, constituted an unconscious pattern of what we have come to see as an intuitive ritual, divorced from any religious or esoteric system, a re-enchanting of space that is unconnected to dogma or a priesthood, but instinctively creative and democratically initiated.

Fourth, and connected to our third finding, the movement of water is a common feature of what we have come to think of as abject privileged points. According to the French philosopher of technology Gilbert Simondon, ancient privileged points were essential to sustaining the magical mode of life for ancient humans. The 'magical mode' was the life of magical unity pre-dating any division between subject and object in culture, in which an increase in being free was improvised, paradoxically, by entanglement with other forces. Privileged points were times, places and ideas where there was an especially intense exchange and entanglement of ancient humans with their cosmos. We have begun to notice a meshwork of modern abject equivalents which seem to encourage a non-systems practice in the magical mode. So, in the damp of Gough's cave, tourists toss metal, mostly coins, at the replica bones of 'Cheddar George', our ancient black ancestor, while, in Glastonbury, beside the restrained Edwardian niceness of the Chalice Well, the White Spring (in what was a municipal reservoir) is a place where all sorts of people arrive to make up their rituals as they go along, some paddling and some praying, the sum of which is undogmatic, free of any priesthood, variegated and yet connectable to a

'Pattern' of what remains of recognisable ancient privileged points.

Fifth, and finally, through the waters, the 'magical mode' has stepped forward for us, in a way that was unintended and unexpected. Like a kind of ecological myth-science, we have experienced the throwing forward of a probe-head of immersive ecology, the ripples from which have affected and changed our intentions for art-making. They have influenced a development in which we have moved from Ariadne's thread, through to Arachne's web, and now beyond, to something even stretchier and more flow-like than lines and threads.

On the side of a creek in Plymouth we lay down close to a broken ark. We had been talking about how to make eco-sensual actions that were more subtle and gave more agency to the unhuman than those proposed in the 'Planet Orgasm' eco-sexuality of Annie Sprinkle and Beth Stephens. So we lay down and sank through the 'beach', as deep as it would allow us, into a hidden forest of mycelium web, rhizomes, loam, roots, and so on, understanding viscerally and suddenly that there could be no escape by ark, no technological fix, but that we would best respond to climate crisis by imagining not how to sail away but how best to sink into the dark forest beneath our feet.

So, now, we face a challenge. Can we dissolve our practice in such a way that it can reach down to a different level of webbing, and connect coherently to the flow of nutrients, to where the flows of water in the channels of rivers and creeks and streams and culverts entangle with the flows of the dark forests?

And not just the water; can we connect to the other systems that water flows draw us to? To the grander pattern of pylons, stone rows, chalky paths, motorway systems,

mycelium strings, cave complexes, postal rounds, mineral seams, and so on? For they are all subject to and operate in relation to Simondon's 'privileged points'. They all shape and are shaped by a pattern hidden inside them.

Seeking such an embedding, in buried and hidden systems, might seem to be a counter-intuitive move for artists: to reach for darkness, to seek dissolution and dispersal, to disappear underground rather than strive for climax, focus and expression. To risk irrelevance and obscurity by invoking and navigating a labyrinth that is not only architectural and metaphorical, but also geological and hydrological. Like Polynesian boat travellers, we seek to steer our way by the shapes of waves and currents. To feel our way, but also to allow what we feel to feel us, and direct us by its flows.

About the Authors

Helen Billinghurst is a multidisciplinary artist, educator, researcher and writer. With a background as a film maker, she now works within the expanded fields of painting and drawing. Her recent doctoral research at the University of Plymouth explored the intersection between studio practice and aesthetic walking. She currently lectures at Plymouth College of Art, and her research interests include the performance of making, site-specificity and embodied process.

In 2014 Helen was resident artist for six months at High Cross House in Dartington, Devon. Recent solo exhibitions include 'Crossing England' (Ariel Centre, Totnes, 2016), 'Embodied Cartographies' (Walcot Gallery, Bath Fringe Festival curated by Fay Stevens, 2016), 'English Diagrams' (Royal William Yard, Plymouth, 2018) and 'Walking Diagrams' (Walking's New Movements Conference, University of Plymouth, 2019). Other recent commissions include an article for the catalogue of 'Dear Christine', (a touring exhibition about the life of Christine Keeler, by women artists, curated by Fionn Wilson, 2019).

Phil Smith is a performance-maker, writer and academic researcher, specialising in work around walking, site-specificity, mythogeographies and counter-tourism. With Tony Whitehead and photographer John Schott, Phil recently published *Guidebook for an Armchair Pilgrimage* with Triarchy Press. He is currently developing a 'subjectivity-protective movement practice' with Canada-based choreographer Melanie Kloetzel. With Claire Hind and Helen Billinghurst, he co-organised the 2019 'Walking's New Movements' conference at the University of Plymouth. As company dramaturg and co-writer for TNT Theatre (Munich), he most recently premiered 'Free Mandela', co-authored with TNT's artistic director Paul Stebbings, about the end of apartheid in South Africa. Paul and Phil are presently working on a book about TNT Theatre's

transformation from tiny experimental theatre company to global touring organisation.

Phil is a member of site-based arts collective Wrights & Sites, who recently published *The Architect-Walker* (2018). As well as *Walking Stumbling Limping Falling* (2017) with poet Alyson Hallett, Phil's publications include *Making Site-Specific Theatre and Performance* (Red Globe/Palgrave Macmillan, 2018), *Rethinking Mythogeography* (2018) (with US photographer John Schott), *Anywhere* (2017), *A Footbook of Zombie Walking* and *Walking's New Movement* (2015), *On Walking* and *Enchanted Things* (2014), *Counter-Tourism: The Handbook* (2012) and *Mythogeography* (2010). He is an Associate Professor (Reader) at the University of Plymouth.

Collaborating as **Crab & Bee**, the authors make walks, performances, poetry and exhibitions. They have worked together on an exhibition and walking project called 'Plymouth Labyrinth' (funded by Arts Council England), and a residency at Teats Hill slipway (for Take Apart, Plymouth, 2019). They are writing a new book, *The Pattern,* based on walks across Southern England and Wales.

About the Publisher

Triarchy Press is a small independent publisher of books that bring a wider, systemic or rhizomatic approach to many different areas of life, including:

Government, Education, Health and other public services
Climate Change, Ecology and Regenerative Cultures
Leading and Managing Organisations
Psychotherapy and Arts and other Expressive Therapies
The Money System
Walking, Psychogeography and Mythogeography
Movement and Somatics
The Future and Future Studies

For more books by Phil Smith, Helen Billinghurst, Barry Oshry, John Seddon, Nora Bateson, Russ Ackoff, Sandra Reeve, Graham Leicester, Alyson Hallett, Julian Wolfreys and others, please visit:

www.triarchypress.net

Lightning Source UK Ltd.
Milton Keynes UK
UKHW030445210220
359063UK00008B/820